T0198366

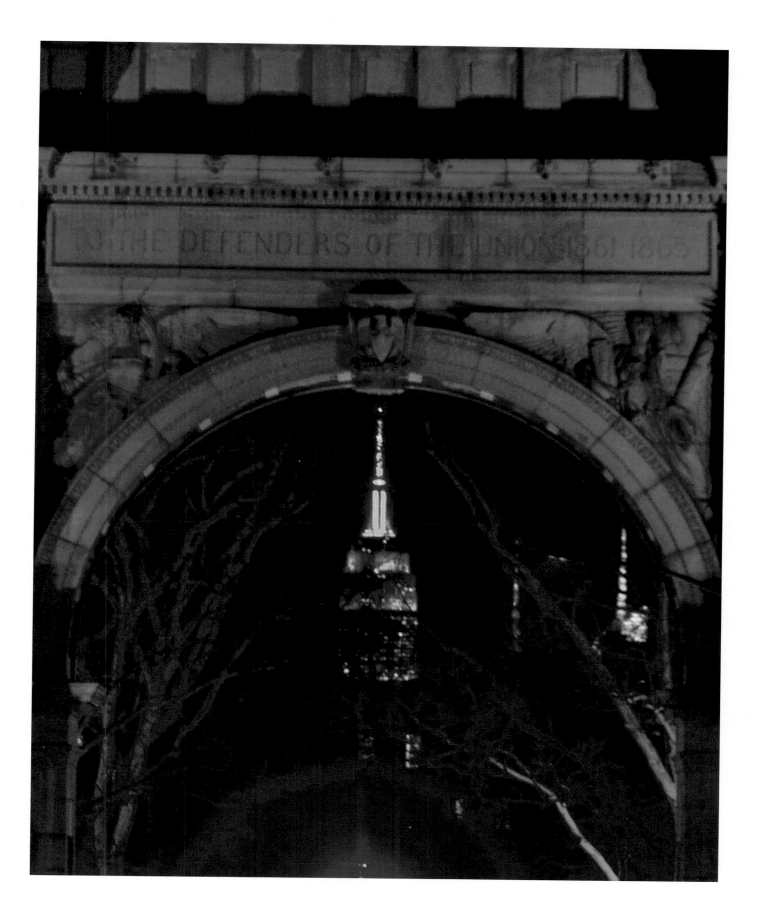

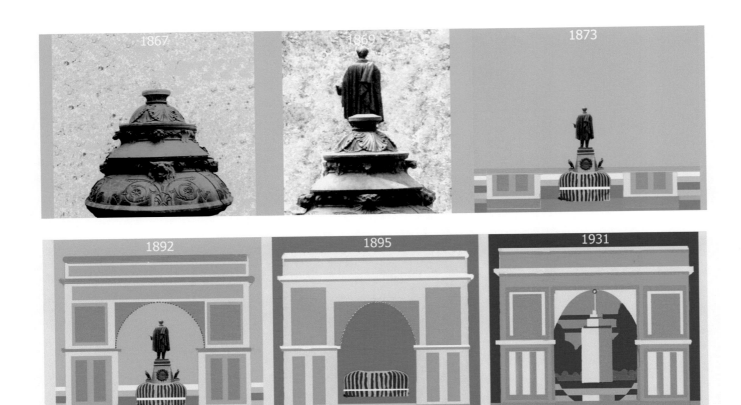

The views expressed in this work are solely those of the author and do not
necessarily reflect the views of the publisher, and the publisher hereby
disclaims any responsibility for them.

To order additional copies of this book, contact:
Xlibris
844-714-8691
www.Xlibris.com
Orders@Xlibris.com

ISBN: Softcover 978-1-6641-7754-3
 EBook 978-1-6641-7753-6

Print information available on the last page

Rev. date: 07/09/2021

"It is a scientific fact that the occasional contemplation of natural scenes of an impressive character increases the subsequent capacity for happiness and the means of securing happiness. Enjoyment of scenery employs the mind without fatigue and yet exercises it, tranquilizes it and yet enlivens it. It has always been the conviction of the governing classes of the old world that it is necessary that the large mass of all human communities should spend their lives in almost constant labor and that the power of enjoying beauty either of nature or art is impossible to these humble toilers."

The Brooklyn Mirador

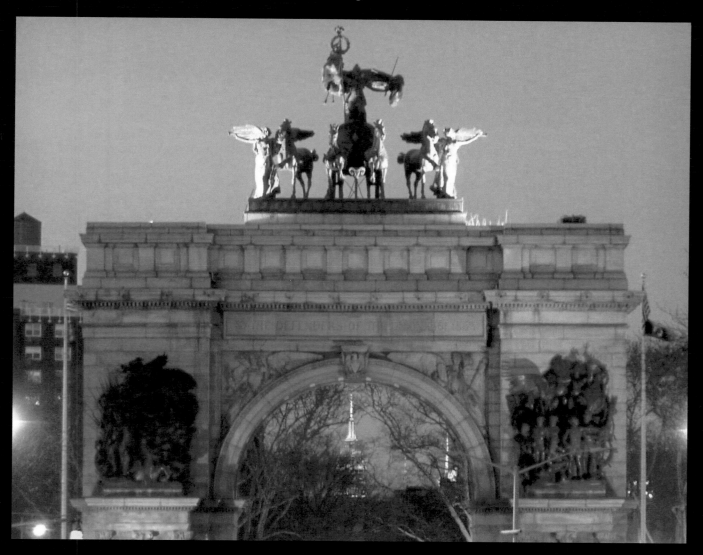

Those Above The Law

"It is the sole duty of government to provide means of protection for all its citizens in the pursuit of happiness against the obstacles which the selfishness of individuals or combinations of individuals is liable to interpose to that pursuit." Olmsted, August 1865

This book was inspired by a series of personal observations and fueled by my family's love of Prospect Park, our backyard. Amazed by the 5.25-mile view of the tower of the Empire State Building precisely bisecting the keystone of Brooklyn's Civil War Memorial Arch at a 90-degree angle, I created and merged timelines of individuals and elements related to the alignment. Based on the results, I believe this view was intentional and is a continuing work-in-progress, initiated by artists whose goal was to civilize our emerging Democracy. As relevant matters come to my attention, this book will be revised. Additional references cited in 'The Brooklyn Mirador – Incomplete Collection, Book Two.'

To Brian, Cordula and Hope

Long Meadow in Prospect Park - "The Emerald Sea"

"It is for itself and at the moment it is enjoyed. The attention is aroused and the mind occupied without purpose, without a thought or perception to some future end." - Olmsted Aug. 1865

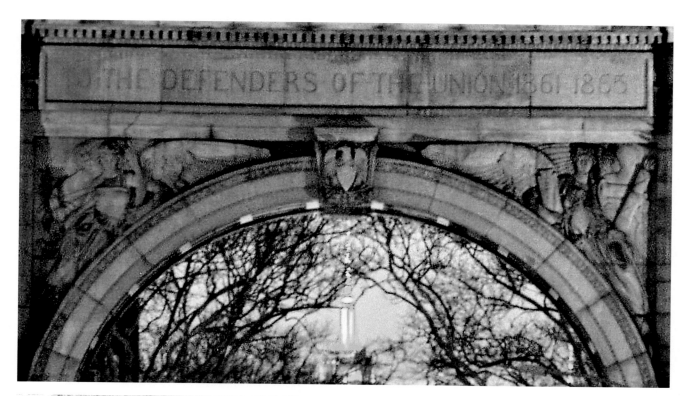

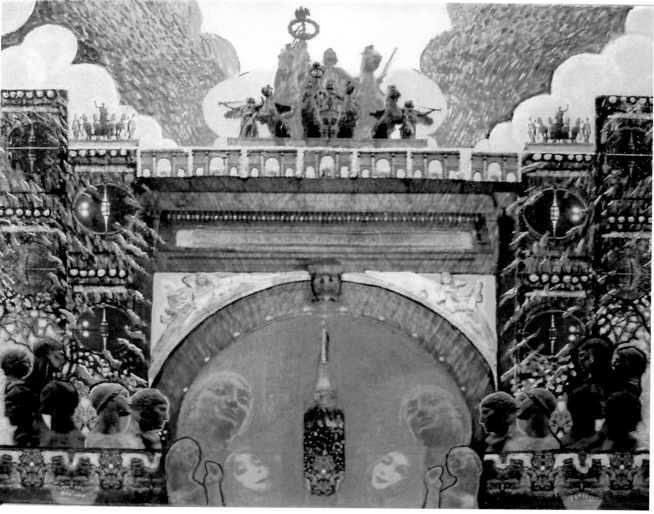

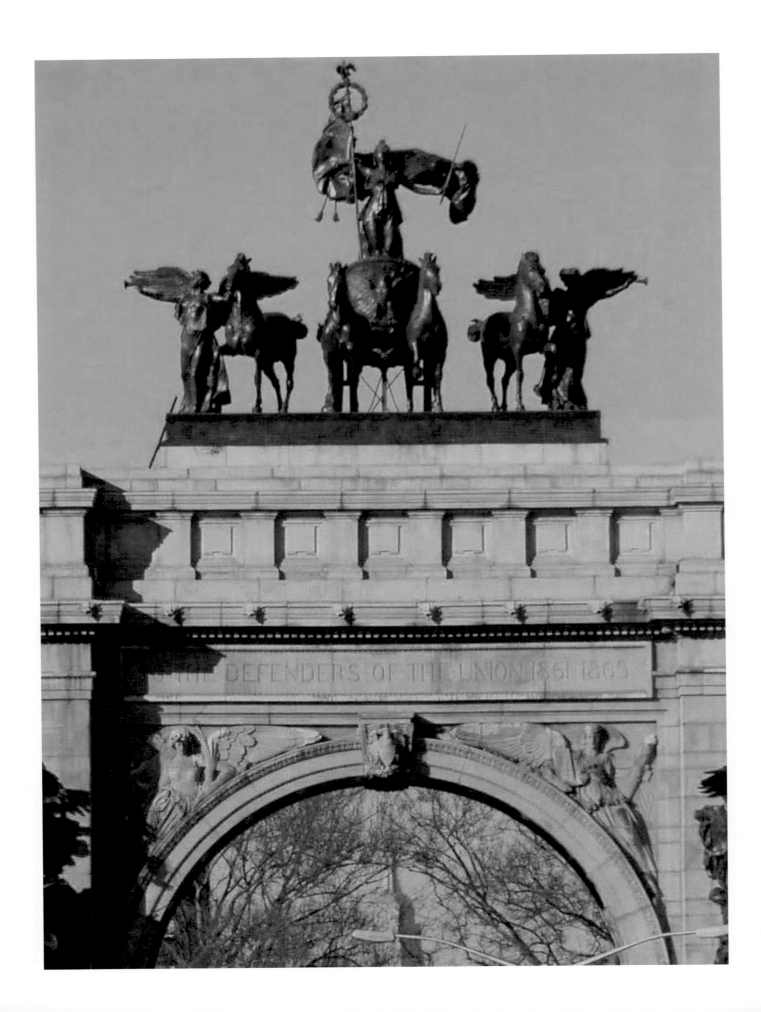

Calvert Vaux and the
View from the Brooklyn Mirador

In 1975, we left a Chinatown loft for a 6-room $200-a-month railroad apartment on 7th Avenue near Union Street. Crossing the park entrance on my way to the library I notice the Empire State Building through the arch. From the crosswalk light it looks like the tower and arch are aligned.

Jan 2008 Renting space in a Gowanus studio ('Brooklyn Artists Gym' - now called 'Trestle' in Sunset Park) I go to the Plaza to work out a painting of the tower and the arch. Shuffling backwards into the park, up the median, the perspective changes. The tower and arch appear to get closer and closer to each other. Just as they meet, I bang my head into this lamppost. And I take my first photo of the beautiful view.

For 33 years I had a bright idea but the wrong perspective. And someone has already marked the perfect vantage point. The tip of the tower, the keystone of the arch and your head against the lamppost - a 3-point alignment bisecting a very solid arch at a 90-degree angle. Very cool.

I return later for a night photo, but the glare of a street light ruins the view. At home, using my computer, I see the 219 foot Building 6, planned for Atlantic Yards, will eclipse the view.

While working on the painting that will have Brooklyn adopt this View, move the street light and deal with Building 6, I do my version of research in order to bulk up, with history, the back of a nice full color 'Save the View' leaflet.

The history bulks up into these multiple pages.

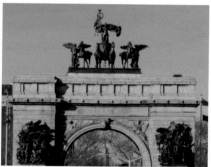

The grassy median and lamppost were planned in 1969, completed in 1970.

I call the lamppost 'The Brooklyn Mirador.'

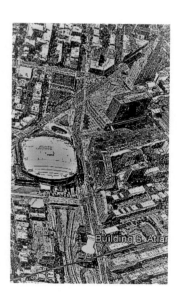

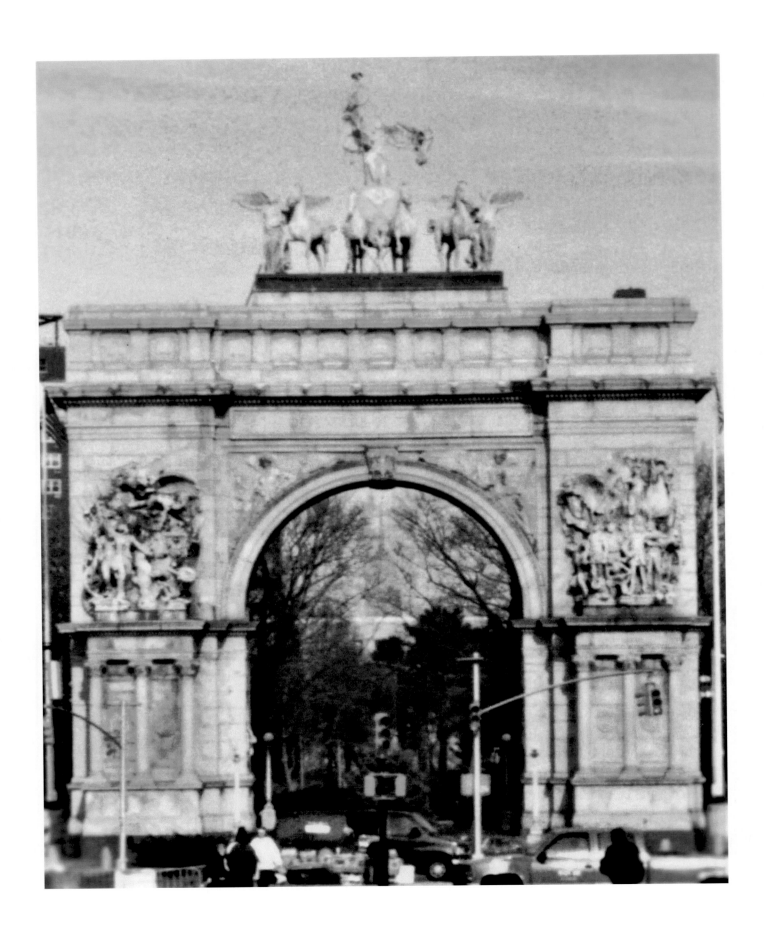

Calvert Vaux and the View from the Brooklyn Mirador

1931 The Empire State Building was built by John Jakob Raskob who resigned as head of GM and DuPont after 10 years to become chairman of the Democratic National Committee. He ran Al Smith for President in 1928, losing to Herbert Hoover. He and Smith then formed the Empire State Corporation. Raskob stood a jumbo pencil on its end to show his architect the building he wanted, an obelisk - and the tallest building in the world. They joined the American Liberty League to fight FDR's New Deal in 1932.

Bailey Fountain was built at the same time as the Empire State Building. Felicity marvels at the tower's beauty. Wisdom ponders history.

This photo shows the first statue dedicated to Abraham Lincoln (1869), the Vaux Fountain (1873), and the arch (1892). They are aligned along the axis of the Plaza (1867).

This axis was designed to provide today's view.

Frederick Law Olmsted and Calvert Vaux ceded control of Central Park to their enemies. Then created their own, the Brooklyn Park. Building the Plaza and defining its axis was the first step.

20 years before the arch, the Lincoln statue faced two Fifth Avenue mansions built on land owned by William Backhouse Astor, 77, an enemy whose group of Manhattan Democrats and merchant elite promised to amend the Constitution to permanently protect slavery to appease the South, running business as usual.

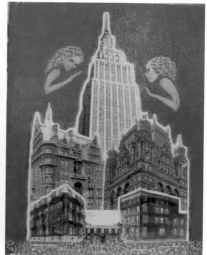

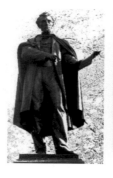

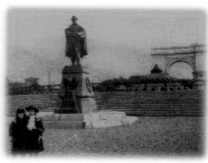

The arch was built. The Waldorf and Astoria Hotels replaced the two Astor mansions.

40 years later, the Empire State Building replaced the Waldorf-Astoria, just as Bailey Fountain took its position along the axis, facing the tower.

In October 1869, the Lincoln statue, Emancipation Proclamation in hand, faced the future tower along this axis.
4 months later at Boston's Lowell Institute, Olmsted, 48, stated:

"A park should be planned
with constant consideration of exterior objects,
some of them quite at a distance
and even existing as yet only in the imagination of the painter."

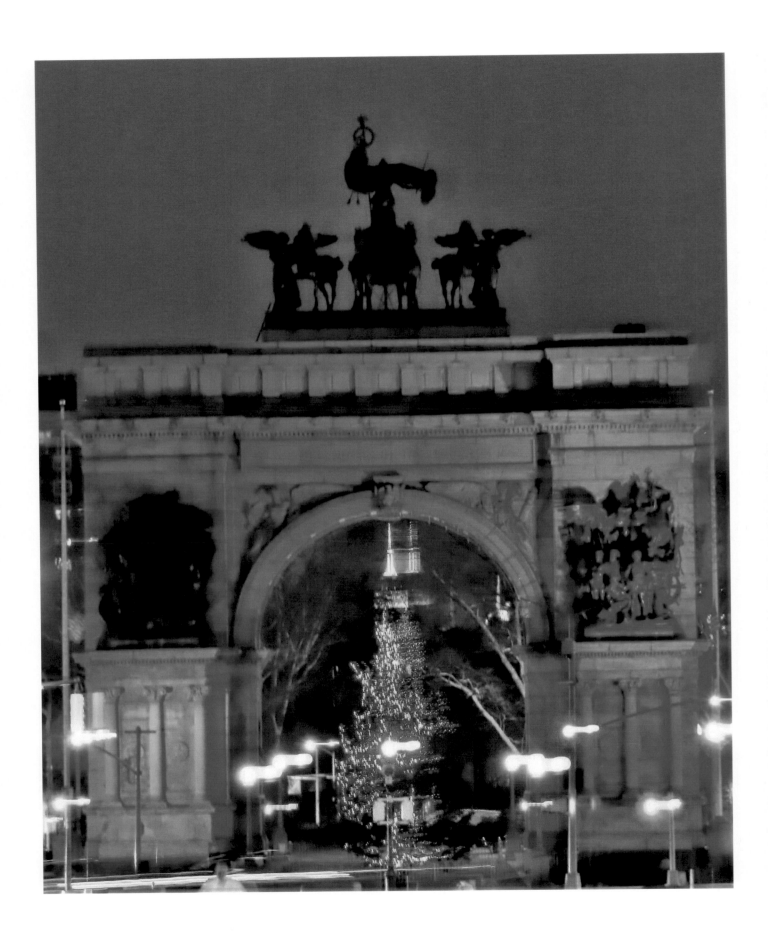

Calvert Vaux and the View from the Brooklyn Mirador

March 10, 1895, (25 years later)

Olmsted, 73, wrote editor William Stiles that the Beaux-Arts architect of the new Brooklyn Park commissioners, Stanford White, 42,

> *"has been and is trying to establish the rule of motives that are at war with those that rule in the original laying out of Brooklyn Park...*
>
> *They have struck down Vaux and are trying their best to kill him in the name of the Lord and of France"*

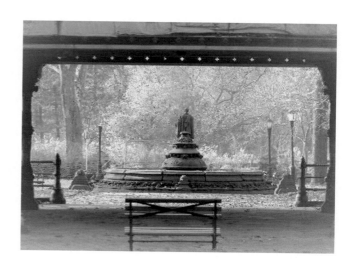

June 1895 - The Lincoln statue is moved to the Concert Grove. With the Oriental Pavilion and the Plaza's original fountain in line, the statue now faced Captain's Pier on Gravesend Bay, where 4'10" 70-year-old Calvert Vaux was found drowned in November.

May 1896 – The U.S. Supreme Court rules that States have Rights to require racial segregation. Emancipation is now 'separate but equal.'

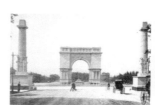

1898 – The humble Arch is draped in statuary, with a quadriga on top, confronting the Park.

1965 - Two years after his assassination, a bust of John F Kennedy was dedicated on the spot vacated by the Lincoln statue 70 years earlier.

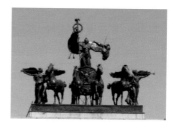

No median in these earlier photos. Notice the location of the people standing in roadway.

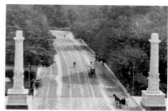

1970 - Two years after the assassinations of Martin Luther King Jr. and Robert F Kennedy, a grassy median was completed on the main roadway leading into Prospect Park - with a lamppost marking the perfect vantage point to appreciate the artists' historic visual corridor.

This was a brief history of the 'View.'

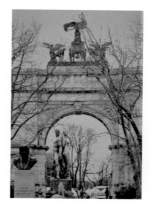

Did the artists, creators of our parks and of this View, have enemies who would strike down Vaux in the name of the Lord and of France? Would this indicate significance in the 'View?'

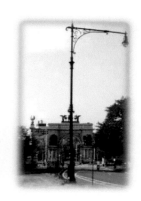

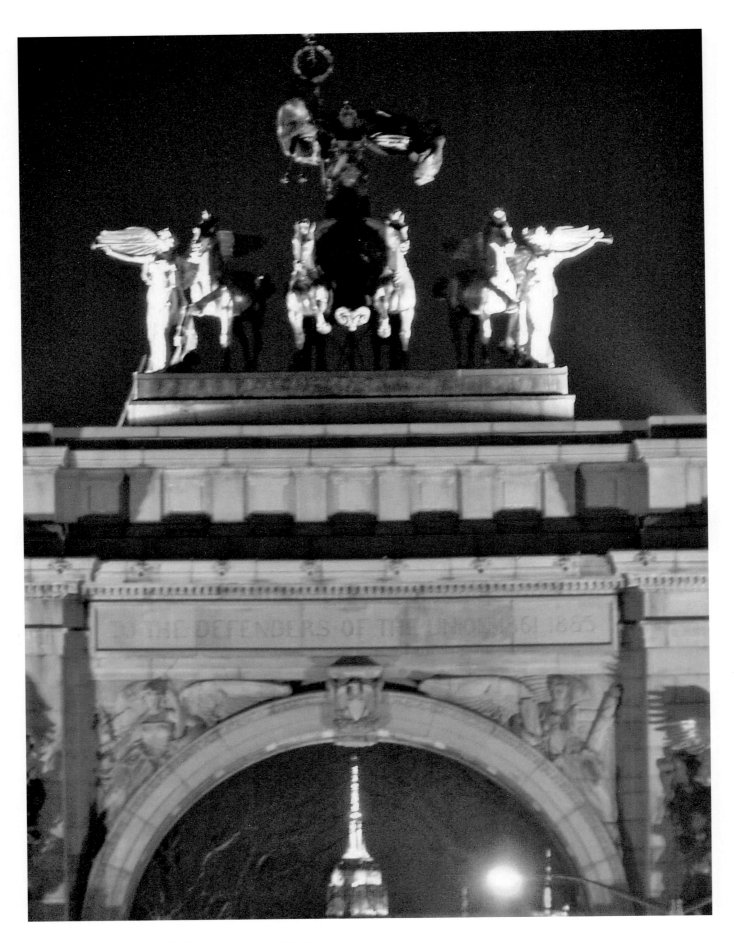

January 1865 (30 years earlier) Calvert Vaux, 40, was hired to redesign Prospect Park. He wrote Olmsted, 43, asking him to become partners in the Brooklyn Park project.

(Following the July 1863 Draft Riots, Olmsted moved to California and was managing gold mines. Abraham Lincoln had appointed Olmsted Executive Secretary of the United States Sanitary Commission to provide health care for Union troops in June 1861. Olmsted proposed conscription with a substitution clause in July 1862.)

03/12/1865 Olmsted to Vaux (The Papers of Frederick Law Olmsted – 5: 324)

> *"I abhor the squabbles with the __Central Park__ Commission and politicians…*
> *It was __a passion thwarted__ and my whole life is really embittered with it very much…*
> *I should like to show you what I could do with a moderate degree of freedom*
> *from the necessity of accommodating myself to infernal scoundrels…"*

>> ***02/09/1861 Olmsted wrote that Central Park Commissioners
>> *"Belmont and Fields have both been doing all the harm they could from*
>> *the adoption of the plan. They have thrown every possible obstruction in*
>> *the way of business and this with direct and avowed intention."* (III:324)

> *"Your plans are excellent, you go at once to the <u>essential starting points,</u>*
> *and I hope the [Brooklyn] commissioners are wise enough to comprehend it."*

05/12/1865 Vaux to Olmsted (5:362-3)

> *"Now comes our opportunity…*

> **__The Brooklyn Park is all our own…__**

> *I value these affairs as opportunities to develop the earnest convictions of my life…*
> *I want to make a 'frightful' example of the Central Park Commission so*
> *that in the end these moneyed men may find that* artists are their masters.

Olmsted and Vaux create the Plaza and define its axis, the essential starting point.

Among their chief enemies on the Central Park Commission was August Belmont.

11/5/1862 – Olmsted to Oliver Wolcott Gibbs (IV:467)
Belmont would *"have a privileged class in our society, a legal aristocracy."*

7/4/1863 – Olmsted to Henry Whitney Bellows (IV:640)
"Belmont and Barrows would be rulers of the United States,
and the greater their crimes, the greater would be their power."

Olmsted considered him the *"meanest and worst of all elements in our society."* (V:617) and had wanted him hung for activities leading to the 1863 NYC Civil War Draft Riots (FLO - A Biography - page 231). I look at events at the time Belmont came to NYC.

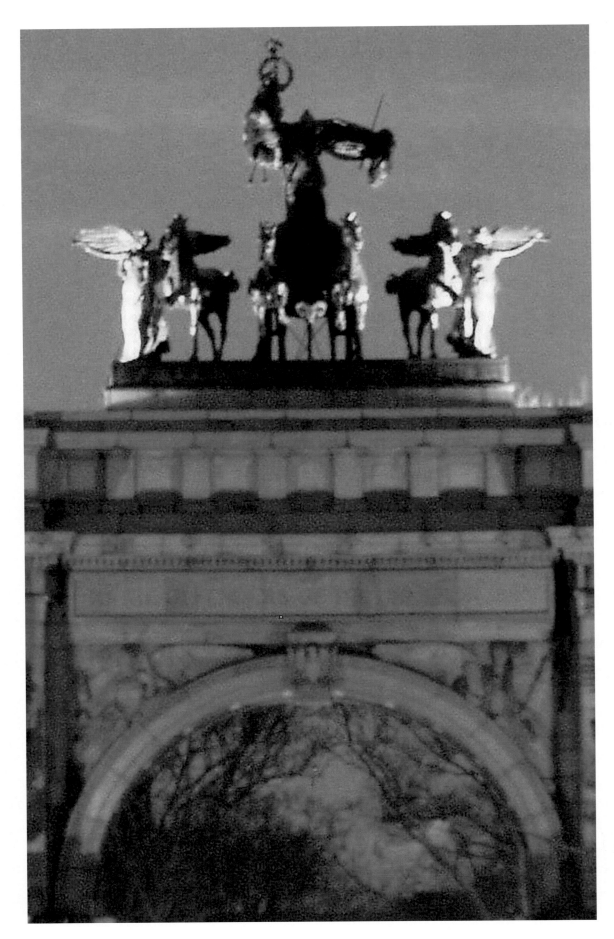

Calvert Vaux and the View from the Brooklyn Mirador

In Paris, in 1836, the Luxor Obelisk and Arch de Triumph are dedicated.

Henry Pierrepont, 28, and the Remsen family sold
a sliver of land for Brooklyn to build Borough Hall.
The cornerstone and foundation were laid in 1836.
John Howard Payne, who wrote the lyrics "There's no place like home,"
jailed by Georgia police for protesting the forced removal of the Cherokee.
Architect Robert Mills submits proposal for the 1885 Washington Monument
- an obelisk and the tallest building in the world.

1837 - A world-wide Financial Panic brings Rothschild Bank's August Belmont, 24,
to NYC, and cheap Brooklyn farmland to Pierrepont. The Astors were buying
distressed Manhattan property and foreclosing on delinquent mortgages, and
Charles Tiffany was opening his first 'fancy goods emporium.'

1838 - Pierrepont establishes Green-Wood Cemetery.

Connecting the tip of the tower of Empire State Building to Borough Hall's dome and
on to Green-Wood Cemetery, a straight line bisects Borough Hall at a 90-degree angle.

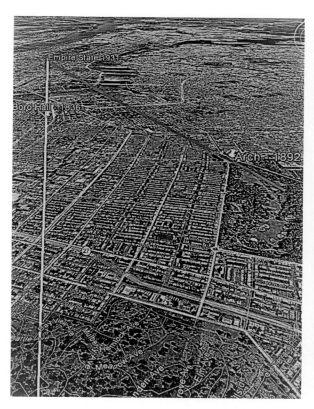 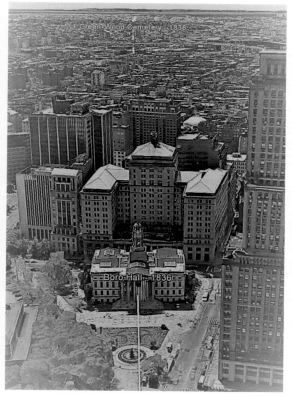

30 years before the Lincoln statue or Prospect Park Plaza's axis,
20 years before the two Fifth Avenue Astor mansions were built,
Henry Evelyn Pierrepont and William B. Astor shared a North/South axis.
What is the Pierrepont Astor connection? Is it significant to the Brooklyn Park View?

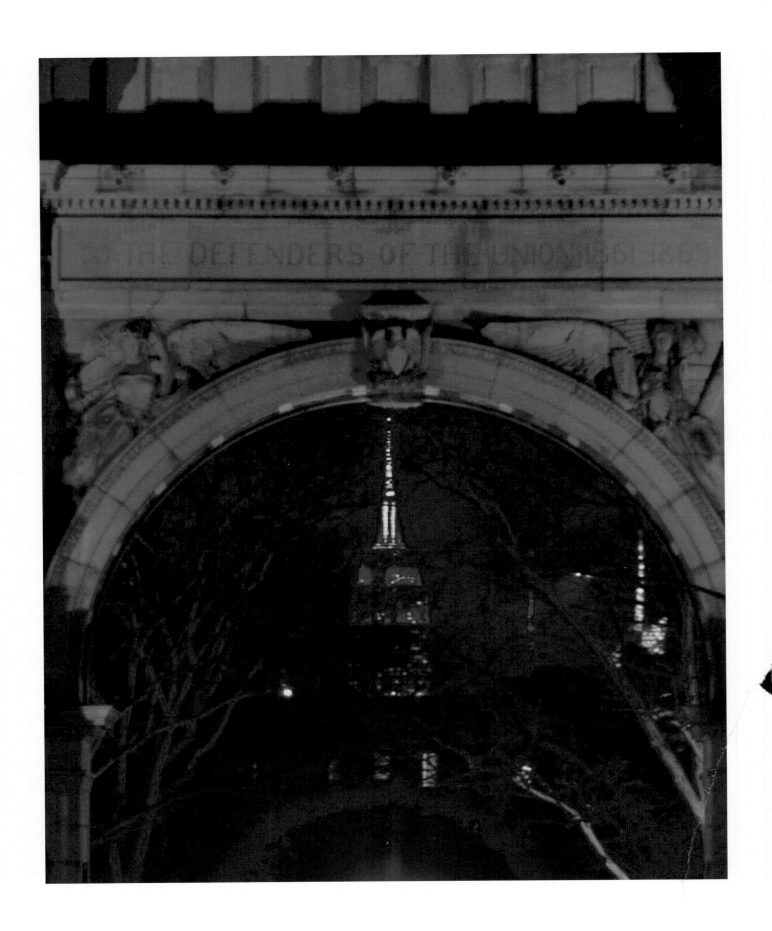

1771 - Henry Pierrepont's grandfather, William Kerin Constable,
 son of an Irish surgeon serving the British in Montreal during the
 French and Indian Wars (1754-63) who then settled in Schenectady,
 was 19 when he returned from Trinity College Dublin to the Mohawk
 Valley. He opened a NYC trading company with an inheritance
 from his Irish aunt and diverted his fur trade from Montreal to NYC.
1781 - Towards the Revolution's end, Constable was aide-de-camp to Lafayette, 24.
 In 1782, he wed Ann White, daughter of Townsend White, a fellow 'Friendly
 Son of St. Patrick.' Their daughter, Anna Maria, was born in 1783.
 Constable and Company was the largest NYC trading company 1784-90.

1784 - John Jacob Astor, 20, arrives in NY. He makes fur trading trips to Albany and
 the Finger Lakes in 1785. And by 1789, establishes a fur depot in the Mohawk
 Valley at Schenectady. Astor joins Masonic Holland 8 Lodge in 1790. In 1792
 he names his heir after benefactor William Backhouse, brother of his London
 fur dealer. John Jacob Astor later became America's first multimillionaire.

1792 – 2 years into the French Revolution, Constable bought millions of acres of unmapped
 NYS wilderness. Additional deeds were drawn up by Alexander Hamilton.

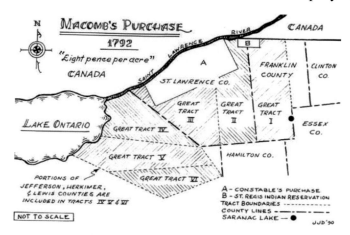

1795 – Constable, 43, following the French 'Reign of Terror,' travels
 to Paris and London, selling parcels of his Empire State land.
1796 - He commissions Gilbert Stuart for 2 famous portraits of Washington, 62.
 One was gift for his friend and lawyer Hamilton, 40. Constable commissions
 his portrait by Stuart, 40. Astor, 32, had done so two years earlier.

1798 - Constable in Europe on business, meets Hezekiah Beers Pierpont.
1802 - Hezekiah, 34, weds Anna Maria Constable, 20. They are gifted
 500,000 acres in upstate NY. Henry Evelyn Pierrepont was born in 1808.

1815 – William Backhouse Astor, 23, returned to NY from the University of Göttingen.
 In 1827, he purchased Thompson's farm, the site of future Empire State Building.
1836 - Pierrepont's Borough Hall and 1838 Cemetery align with the site of the future tower.

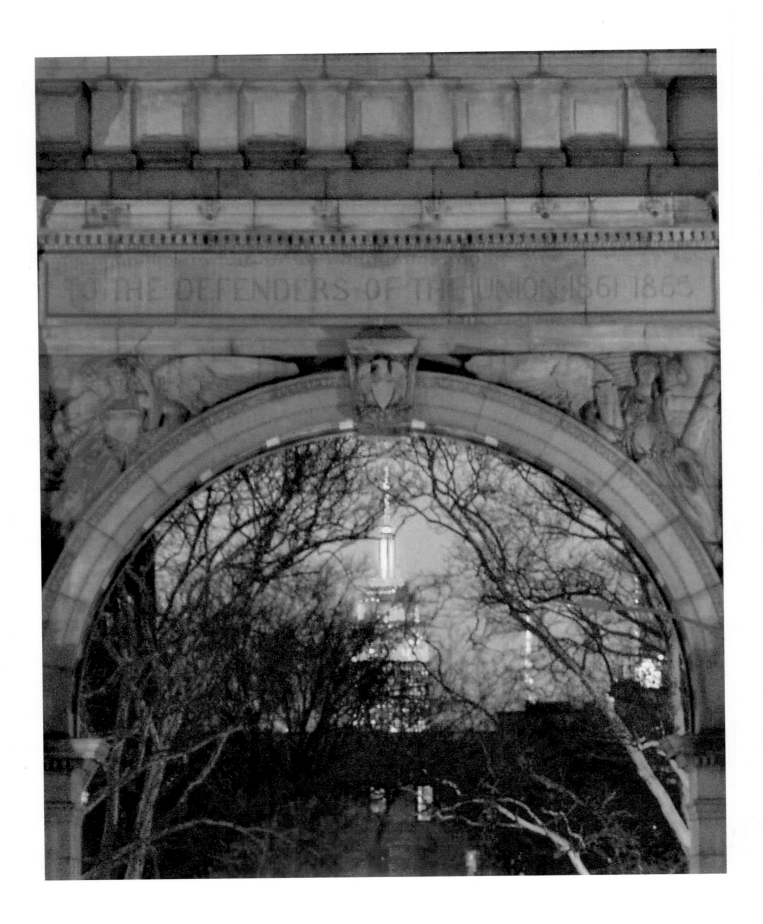

Calvert Vaux and the View from the Brooklyn Mirador

With the 1836 dedication of the Luxor Obelisk and Arch de Triumph in Paris, the three elements the 'Voie Royale' were in place. The alignment of the obelisk and two arches was not viewable until a palace between them was burned down in 1871.

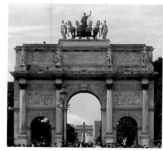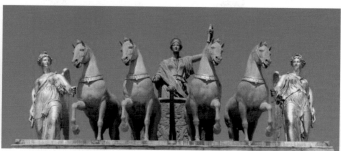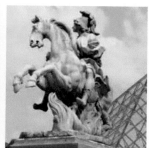

In 1806, Napoleon, 37, had planned an arch on either side of the Tuileries Palace. The Arch de Carrousel was completed in 1808. He was defeated at Waterloo in 1815. The Monarchy returned. In 1828, a quadriga, 'Restoration of the Bourbons,' was put on top of Napoleon's Arch. (A quadriga would claim victory over Lincoln).

Like our Mirador, perspective is important. From the proper elevation, the tip of the Luxor Obelisk will appear to touch the keystones of both arches at once. I. M. Pei's 1989 Glass Pyramid entrance to the Louvre is not on this line. But part of this installation is, an equestrian statue of Louis XIV. The photo of the 'Voie Royale' was taken from the foot of the statue's pedestal. Louis' eyes must mark the perfect vantage point. What artwork in the Louvre held this view before the statue?

1822 – Frederick Law Olmsted is born in Hartford, CT. His Puritan ancestors were among founders of Hartford in 1636, 200 years before Borough Hall and the Arch de Triumph. Was Vaux struck down in the name of the European-style class privilege, which the Olmsted family had escaped some 260 years earlier?

Olmsted and Vaux could see where the grand obelisk of American's privileged class was going to rise. The artists had mastered the moneyed-men of their day, creating great and civilizing respites for the many. Our realization of today's 'View' recognizes that these artists, whose gifts continue to enrich, are masters still, beautifully exposing the point-zero-one-percent's salute to their benefactor.

Our democracy is an evolving and historic work-in-progress, as is this alignment. Regardless the height of the obelisk, at the appropriate time, a mirador on Brooklyn Park's entrance roadway would mark the precise vantage point to evoke this history.

Public awareness and renewed interest in the Plaza may protect this view. Nationwide public interest could be generated by installation of memorials of Presidents Dwight Eisenhower and Lyndon Johnson at the Arch's north faces. Grant and Lincoln on horseback, and Eisenhower and Johnson facing the Tower through Bailey's mist.

"What artist, so noble...directs the shadows of a picture so great that Nature shall be employed upon it for generations, before the work he has arranged for her shall realize his intentions." - Olmsted 1852

'Save the View' petition at change.org

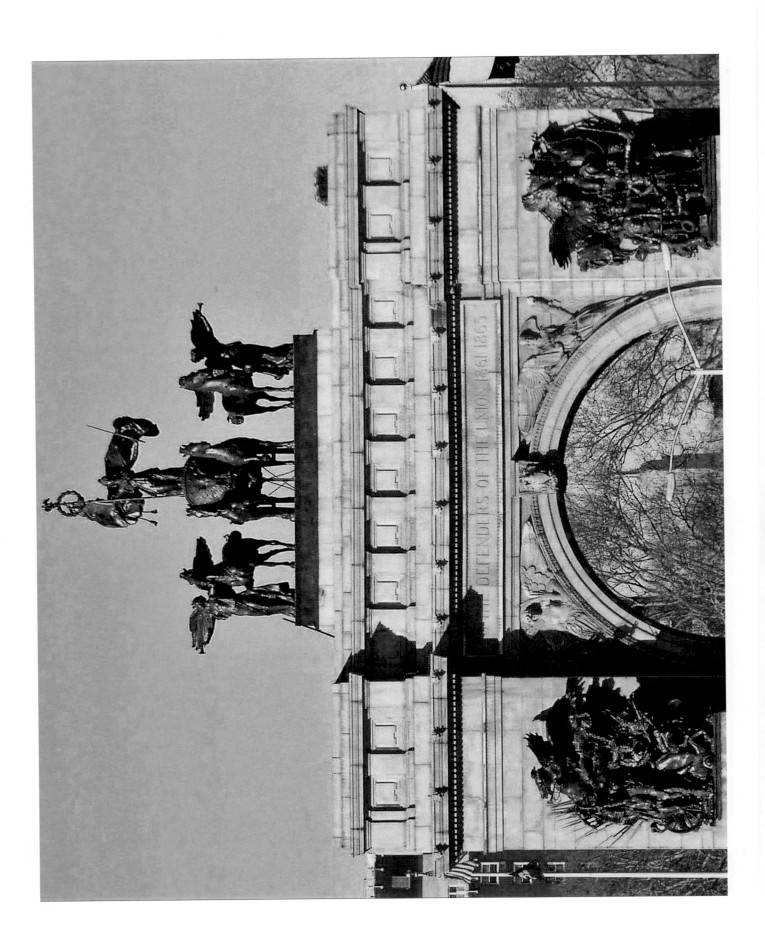

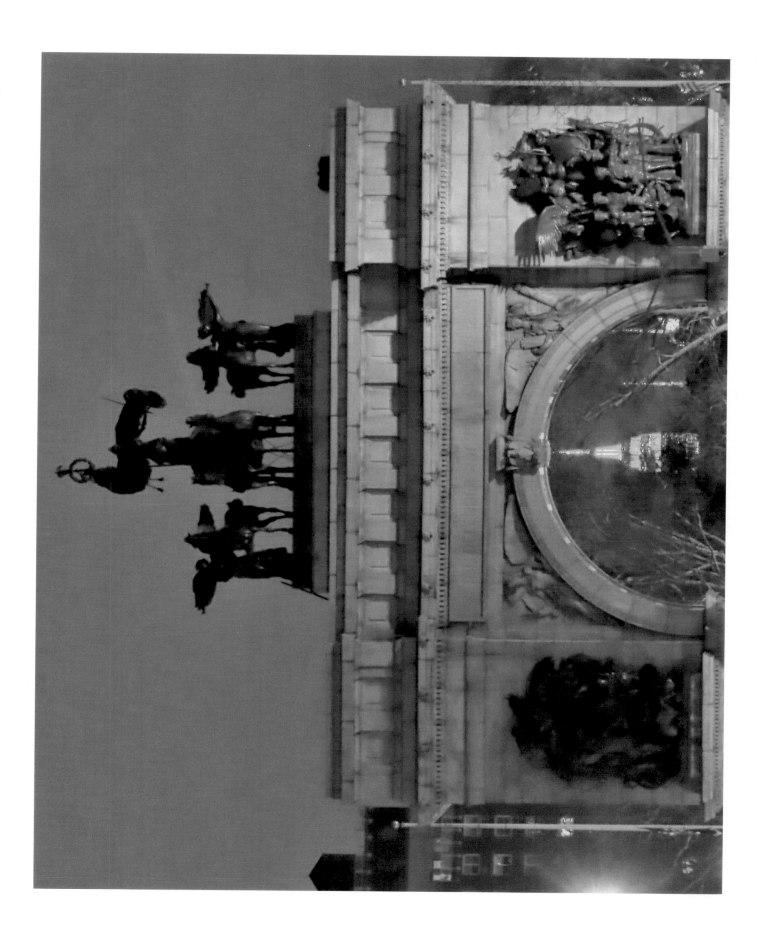

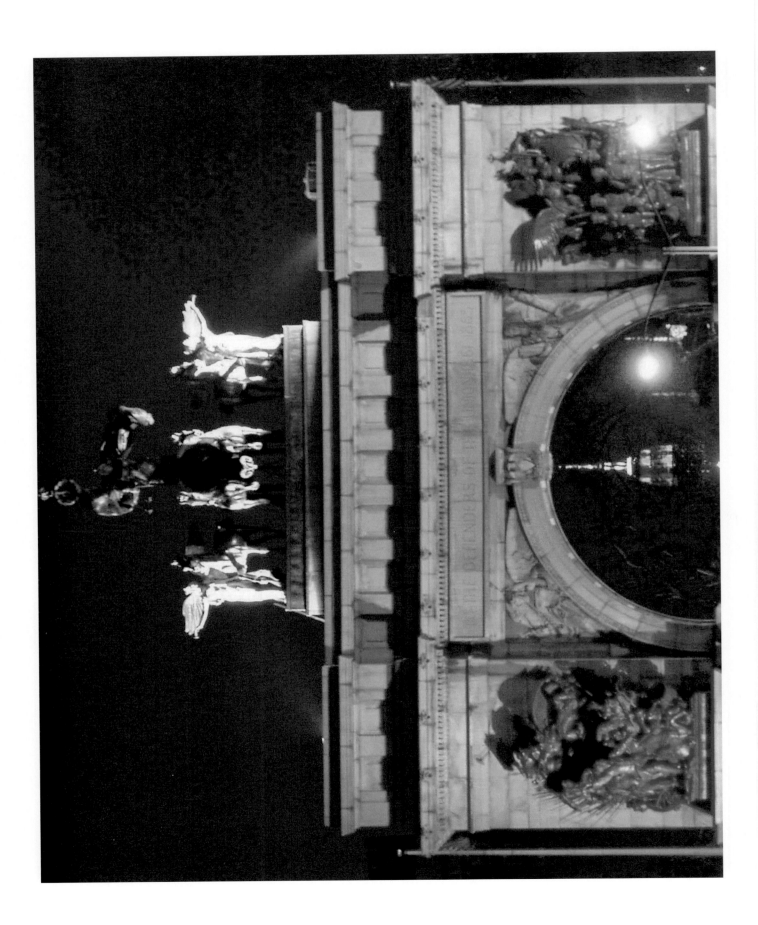

Printed in the United States
by Baker & Taylor Publisher Services